Nudes

copyrighted

ISBN-13:
978-1480150904

ISBN-10:
1480150908

David Price

CreateSpace
Charleston, South Carolina

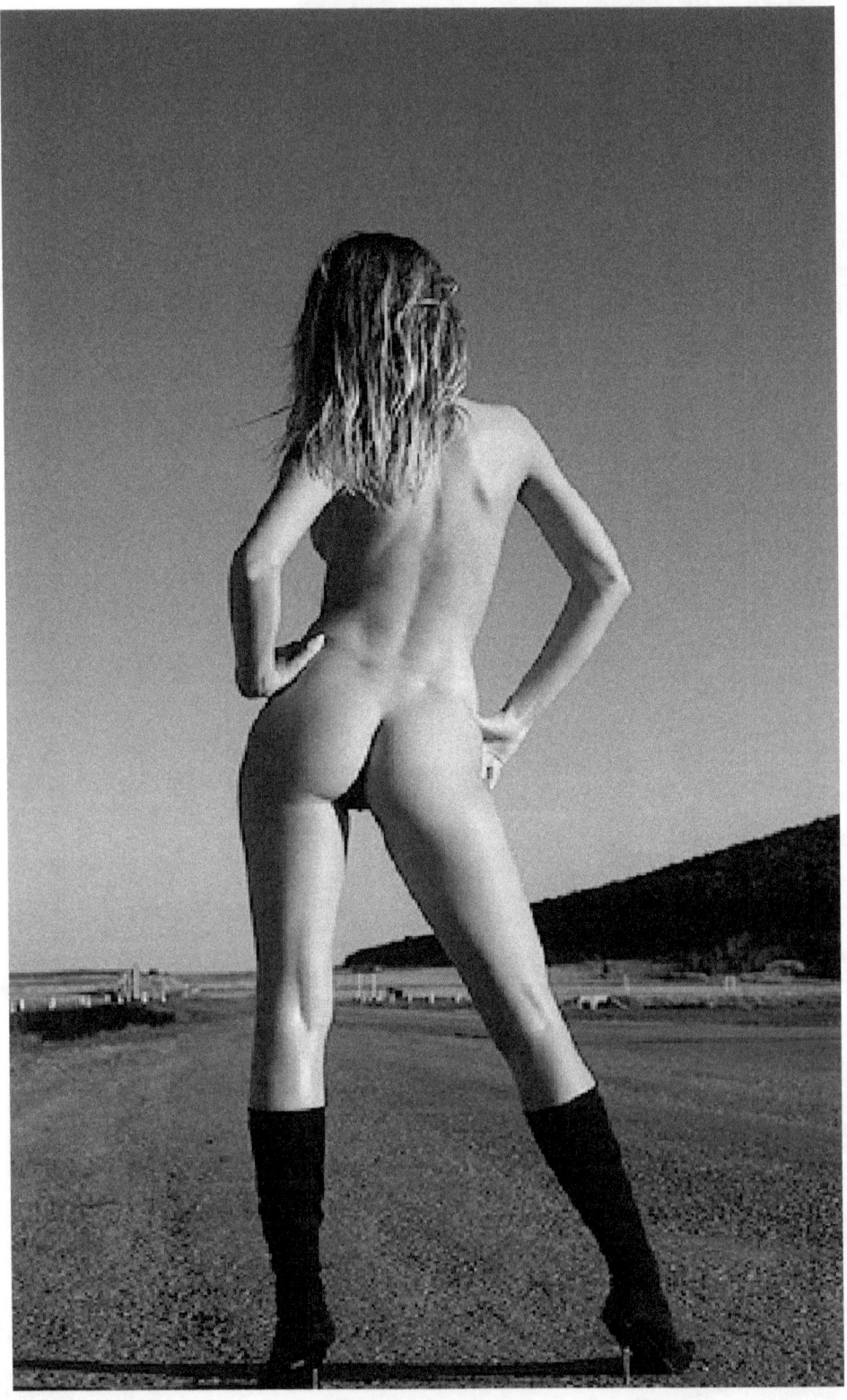

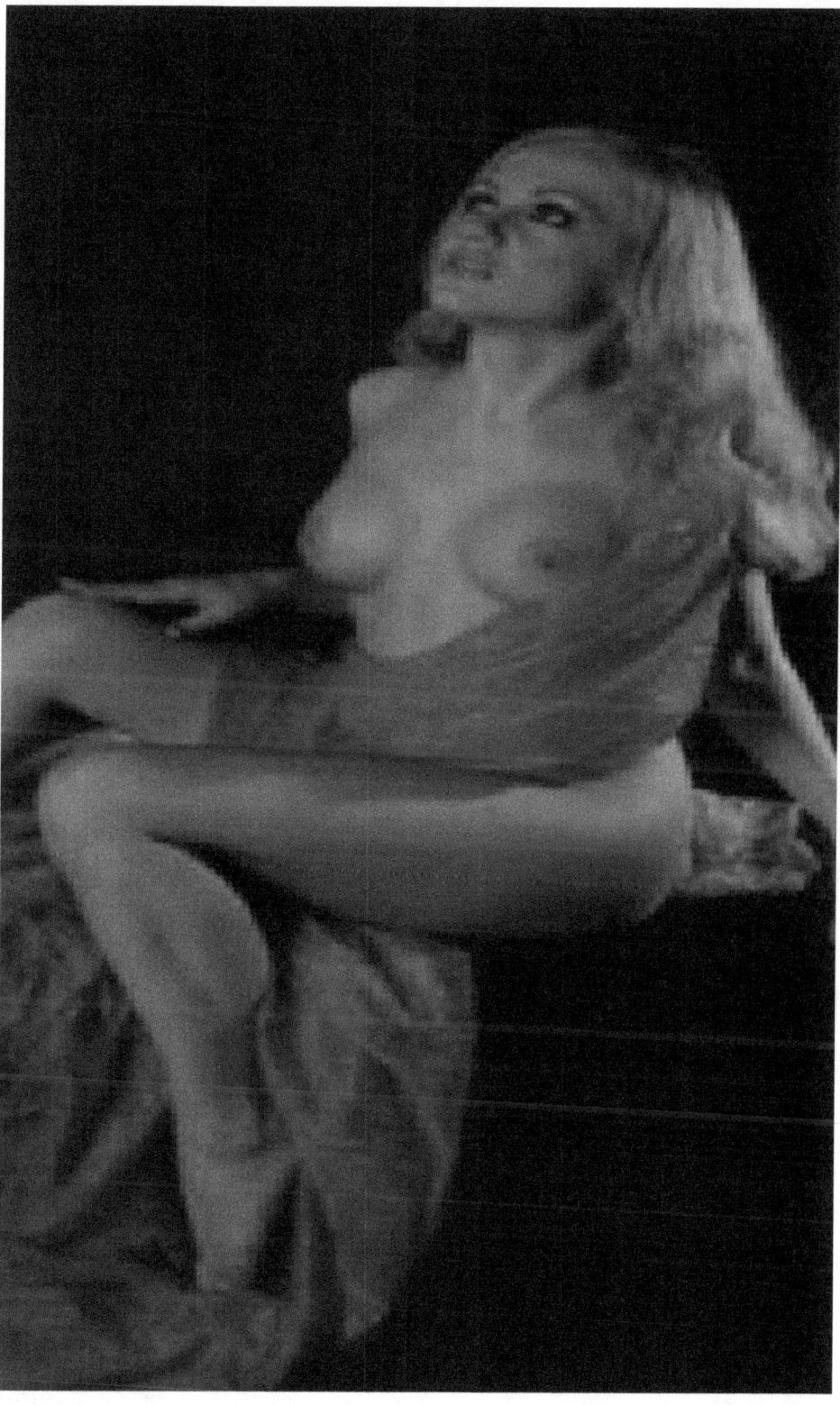

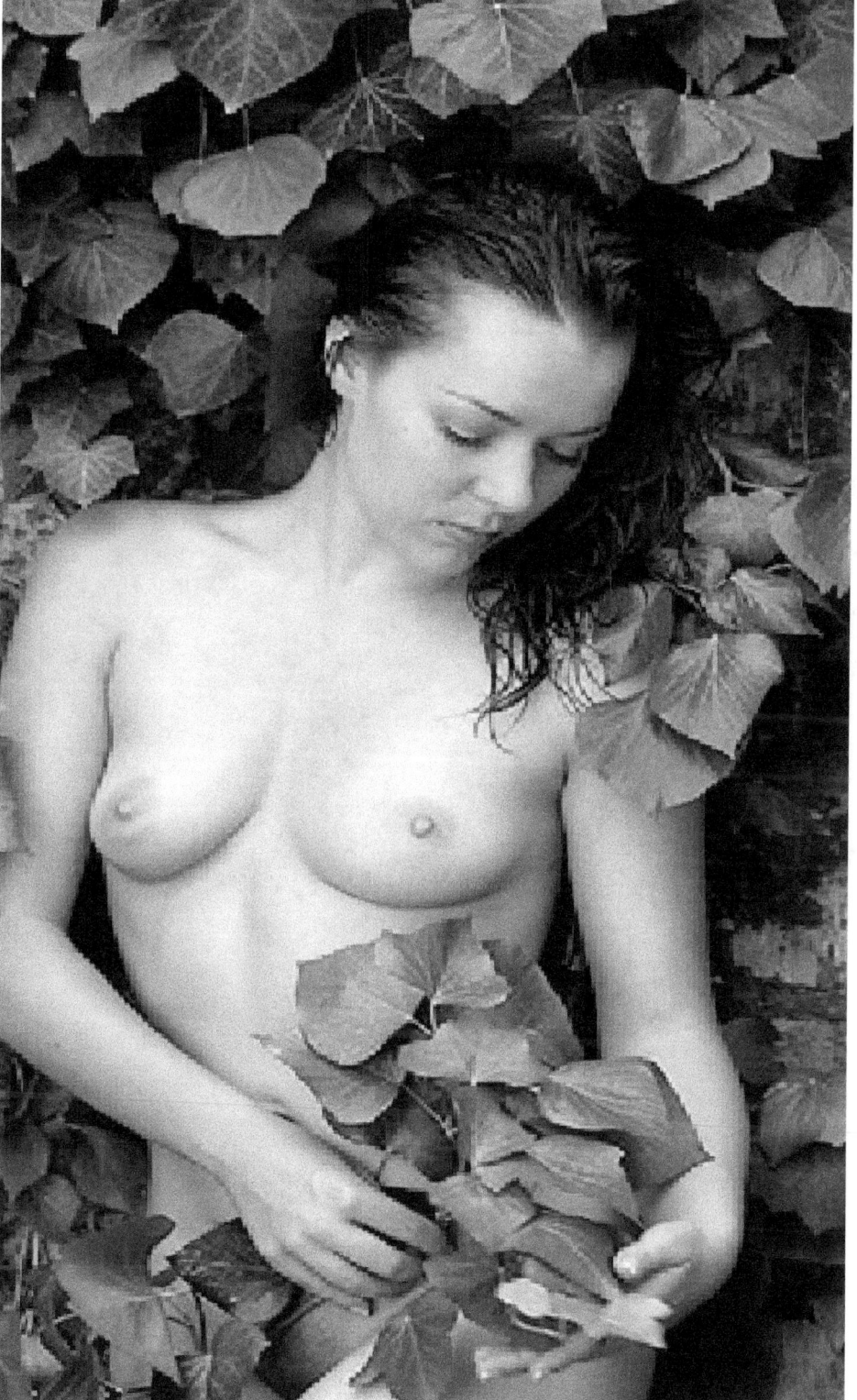

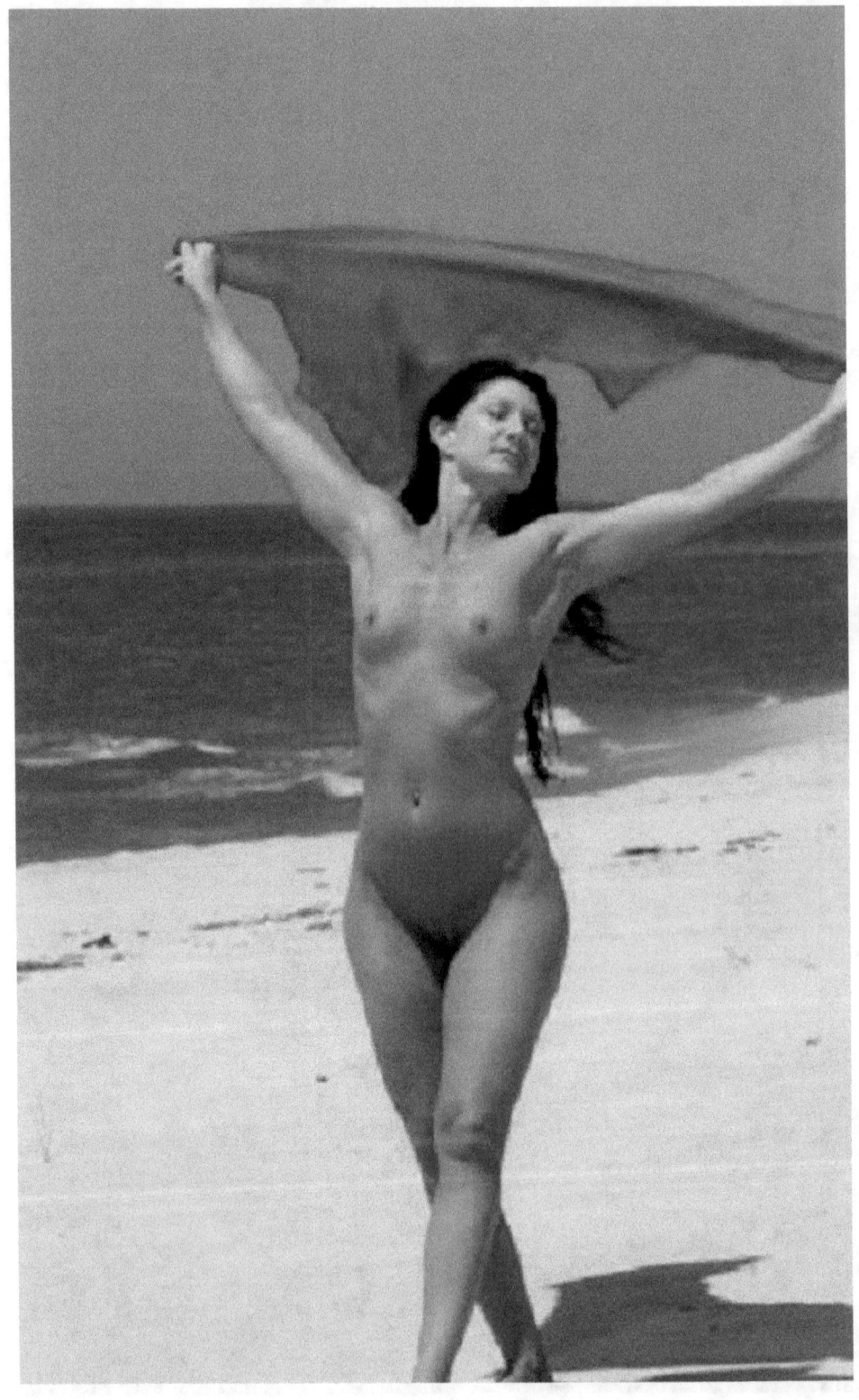

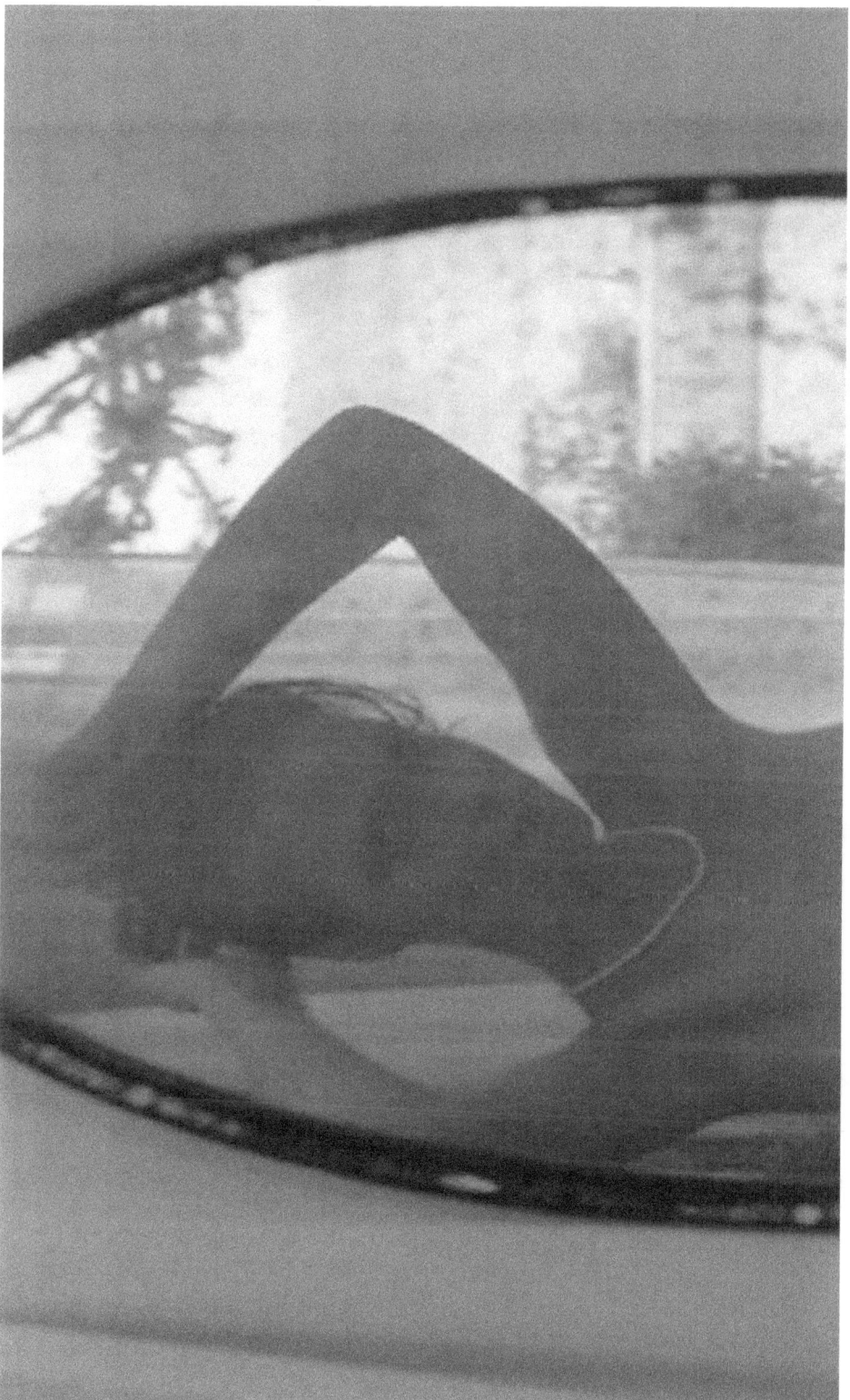

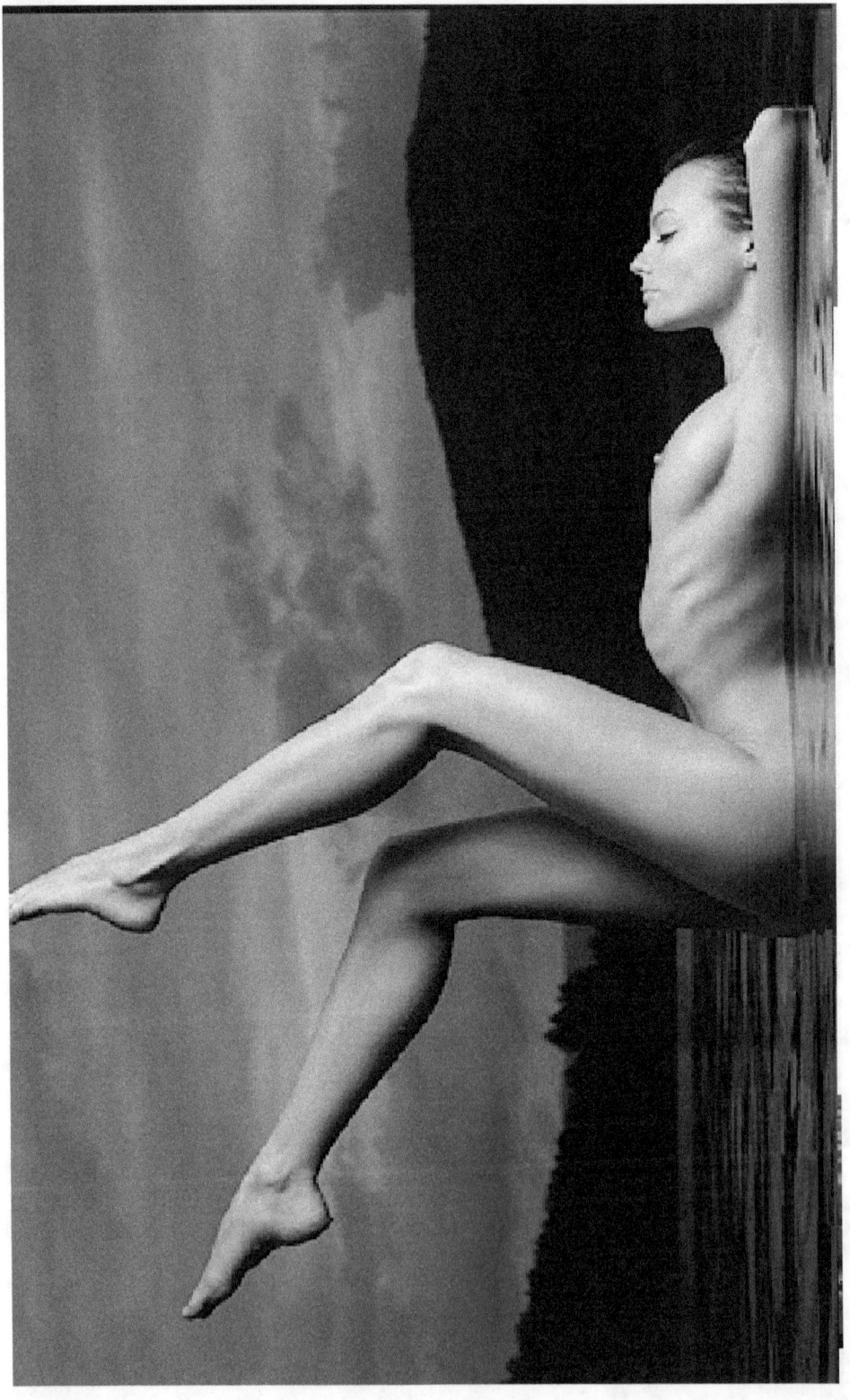

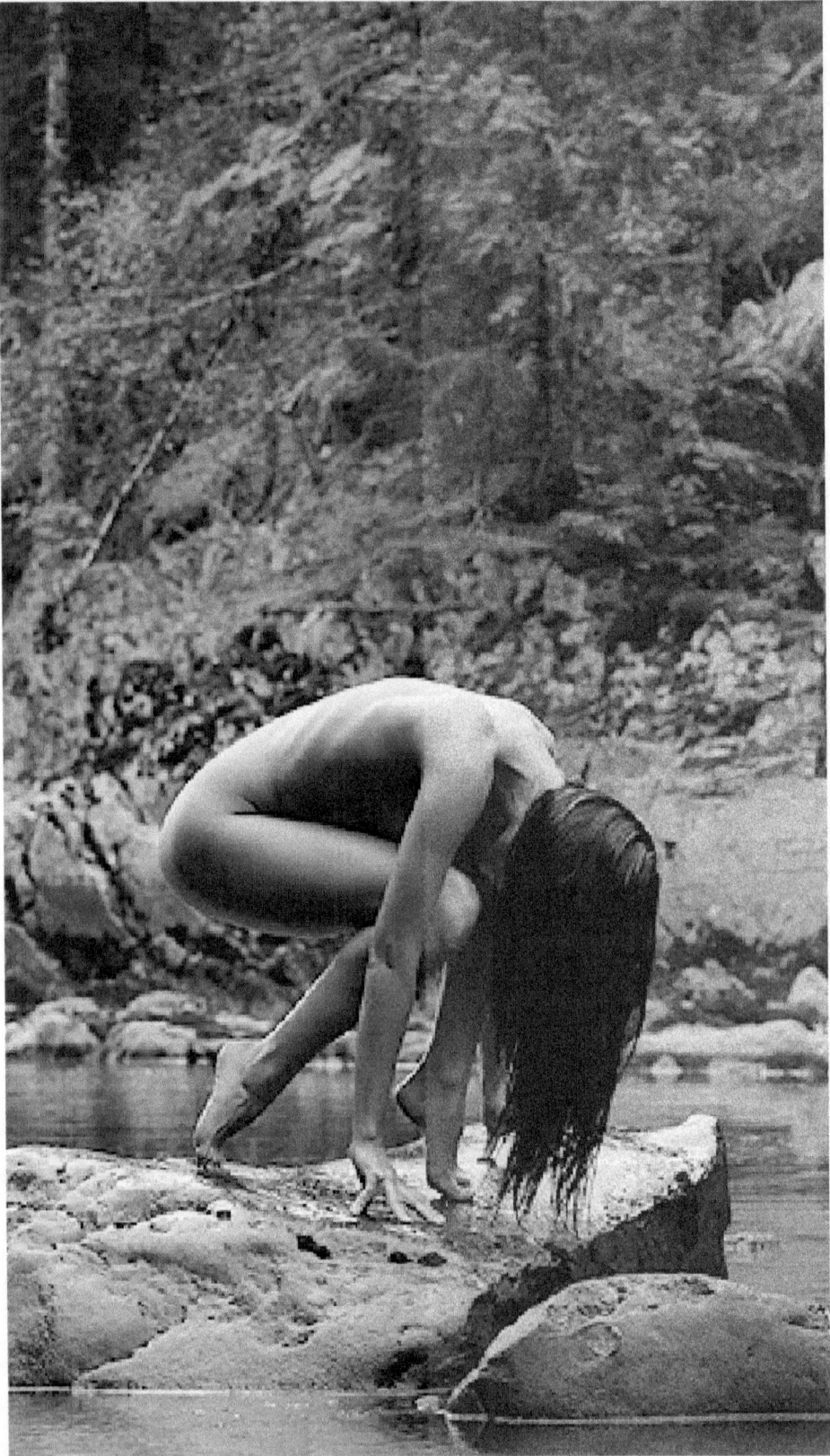

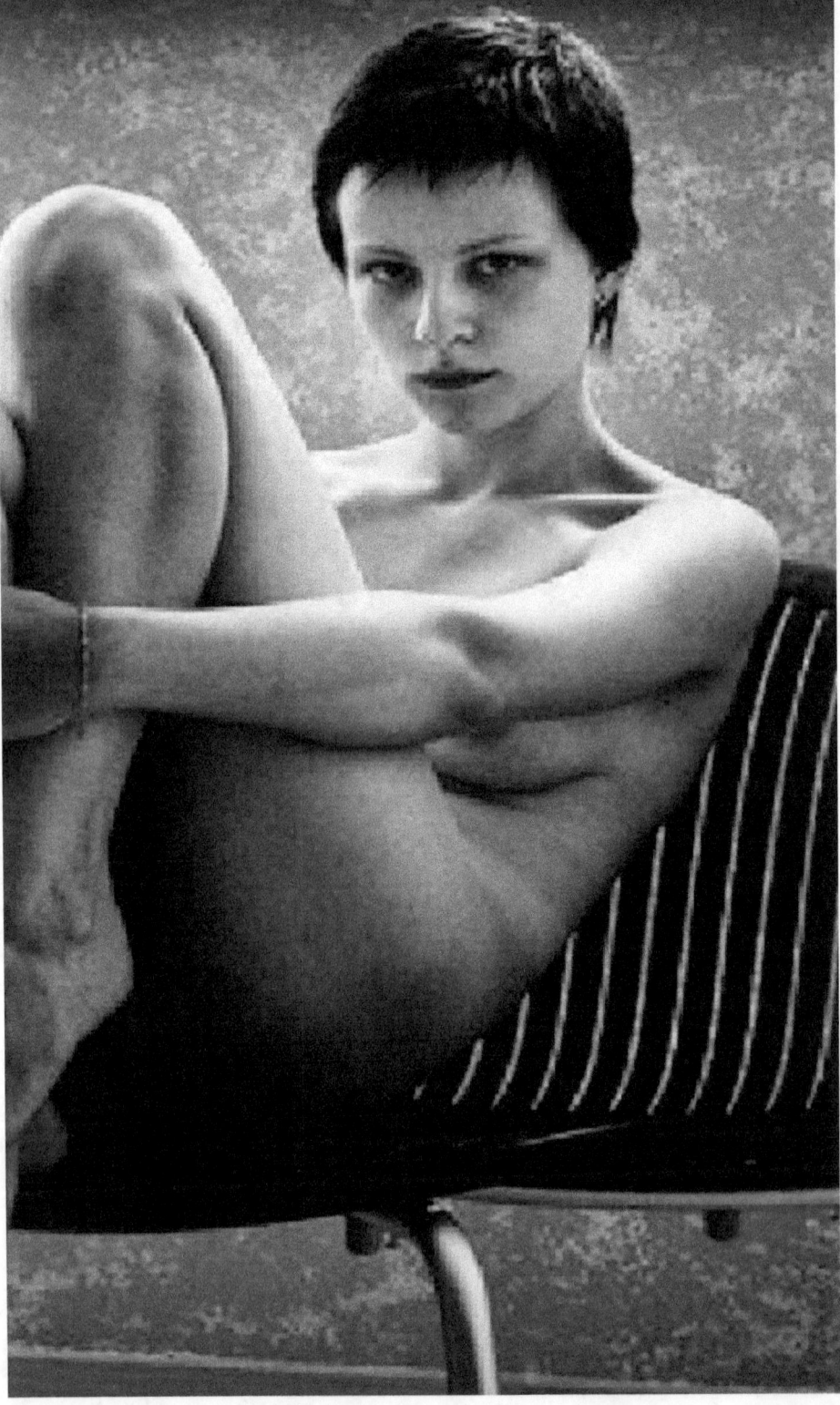

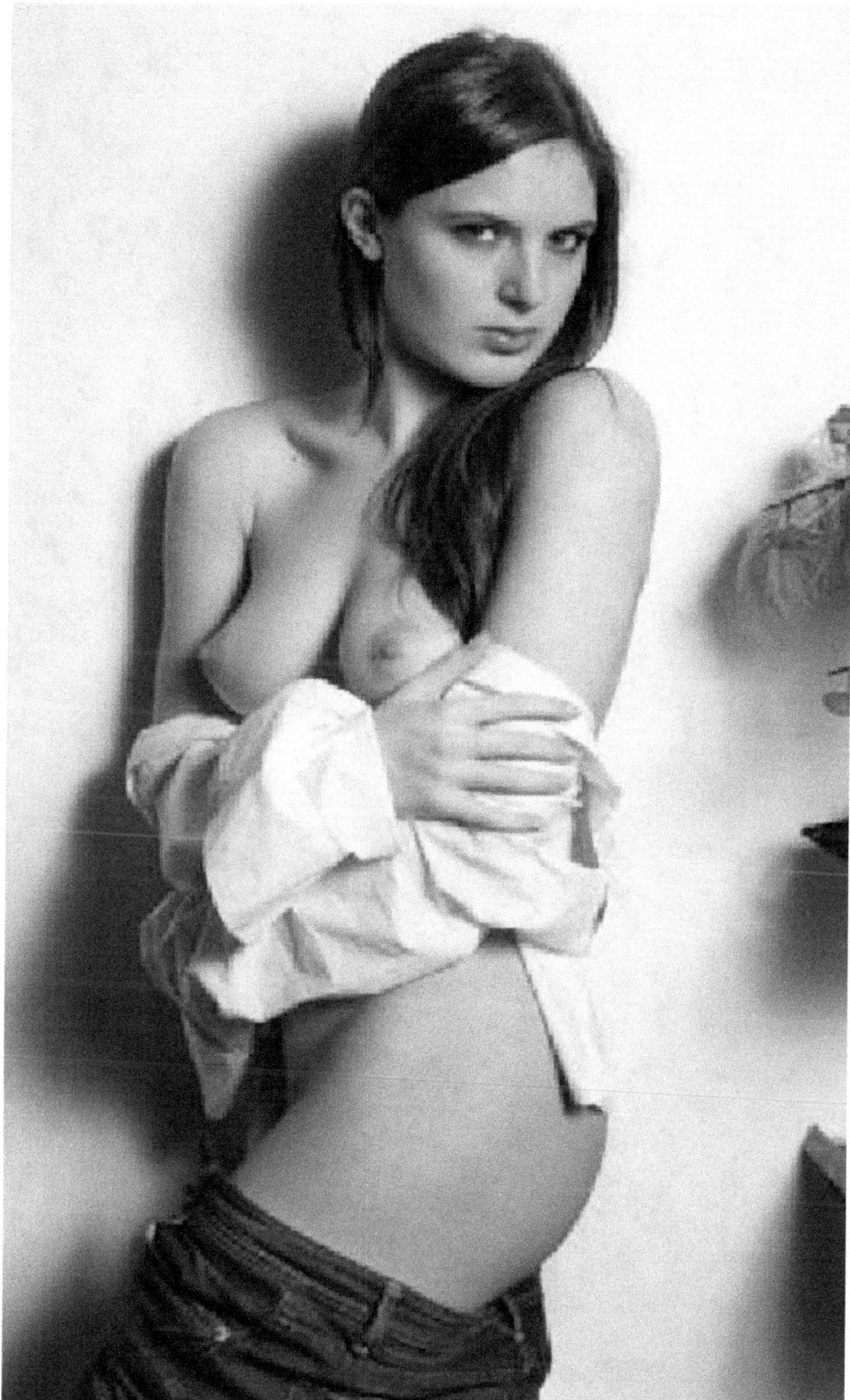

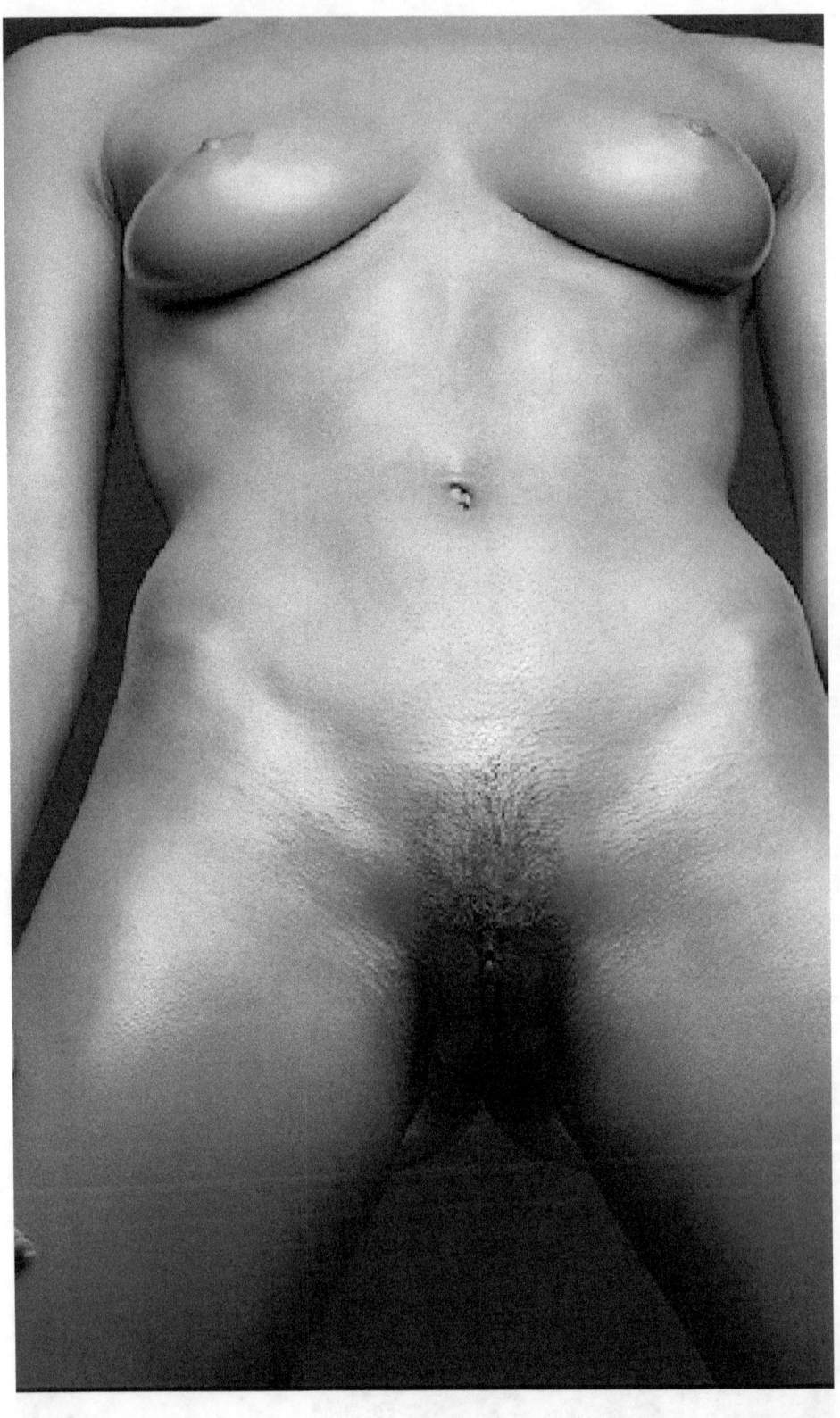

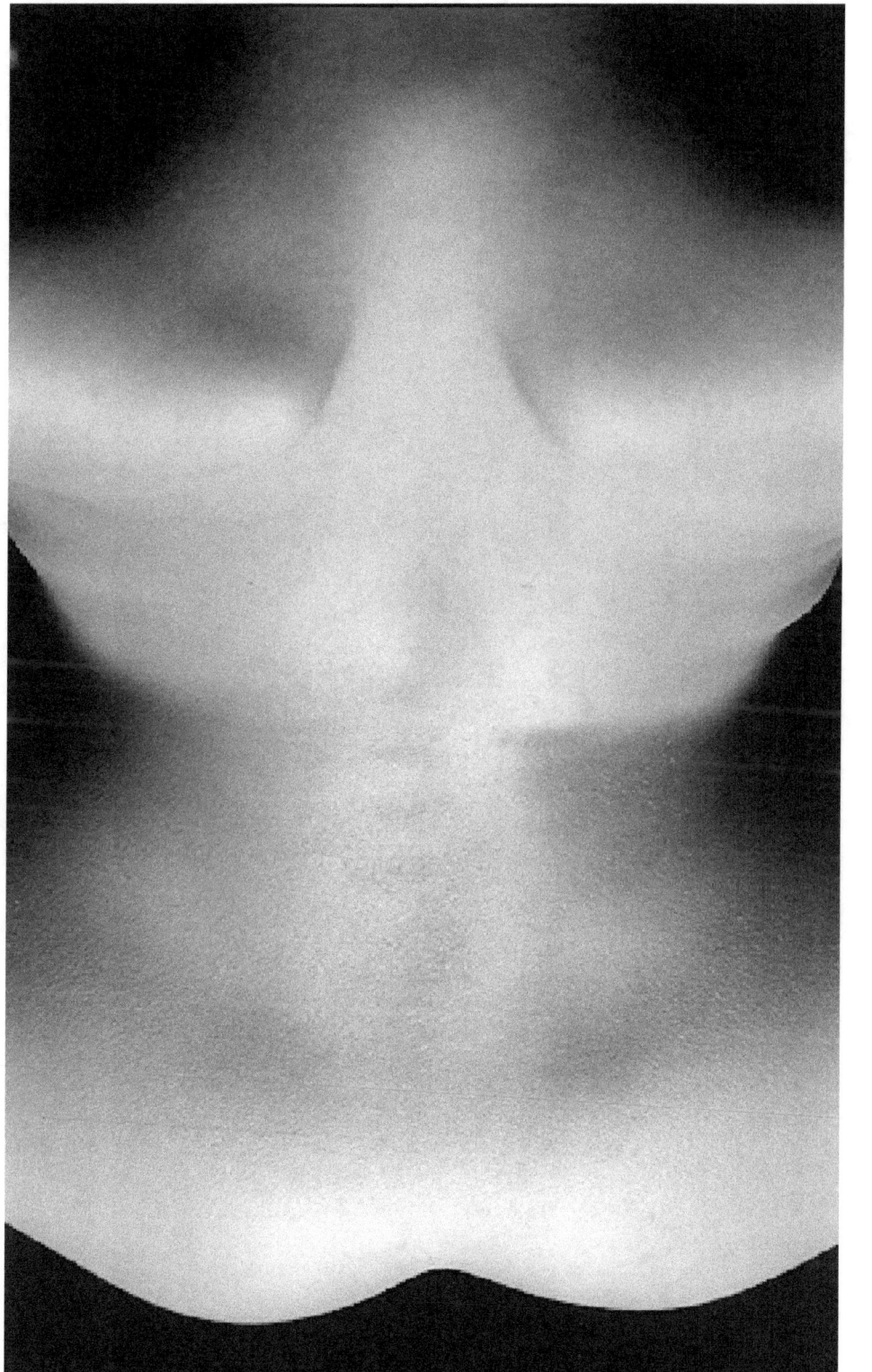

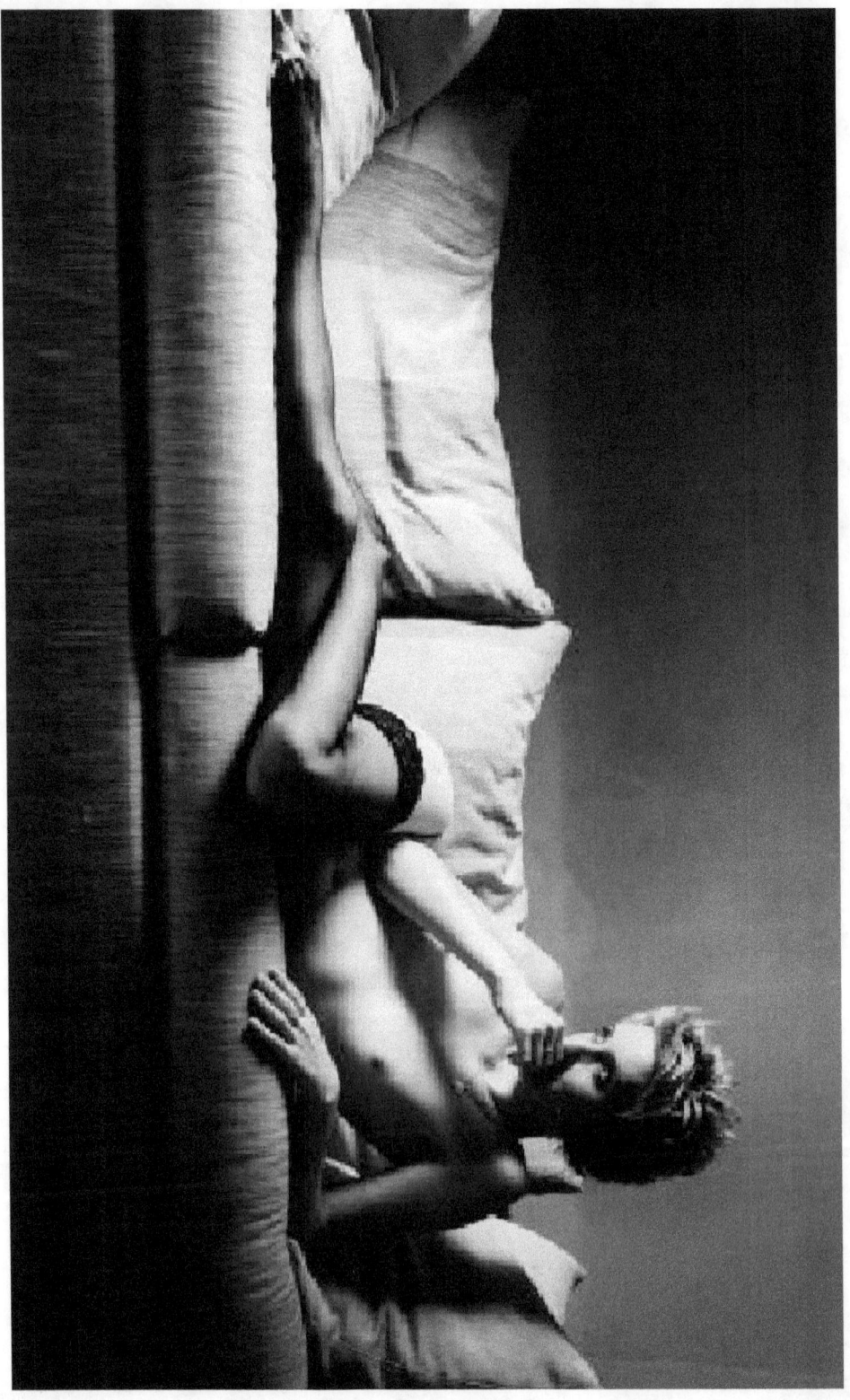

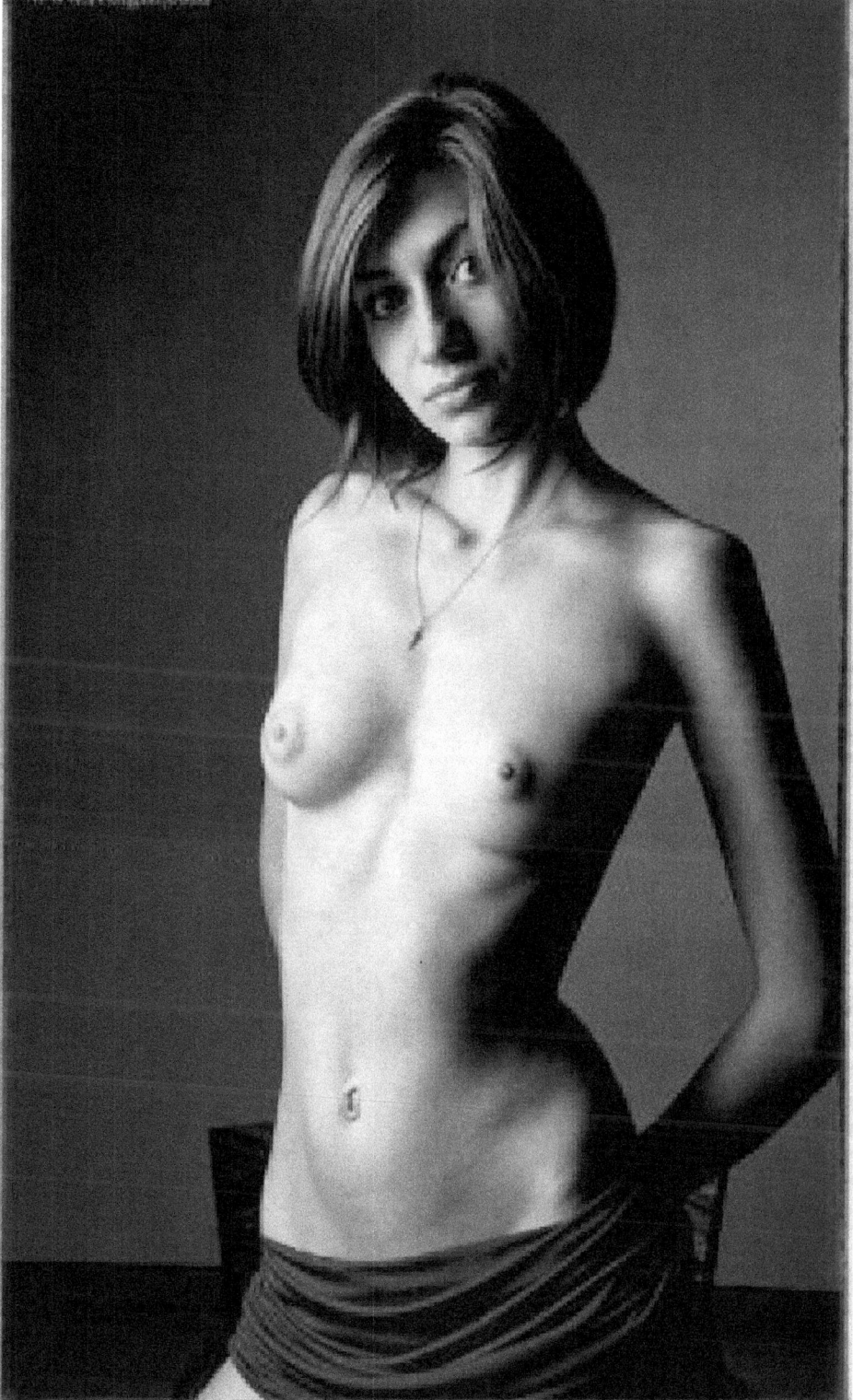

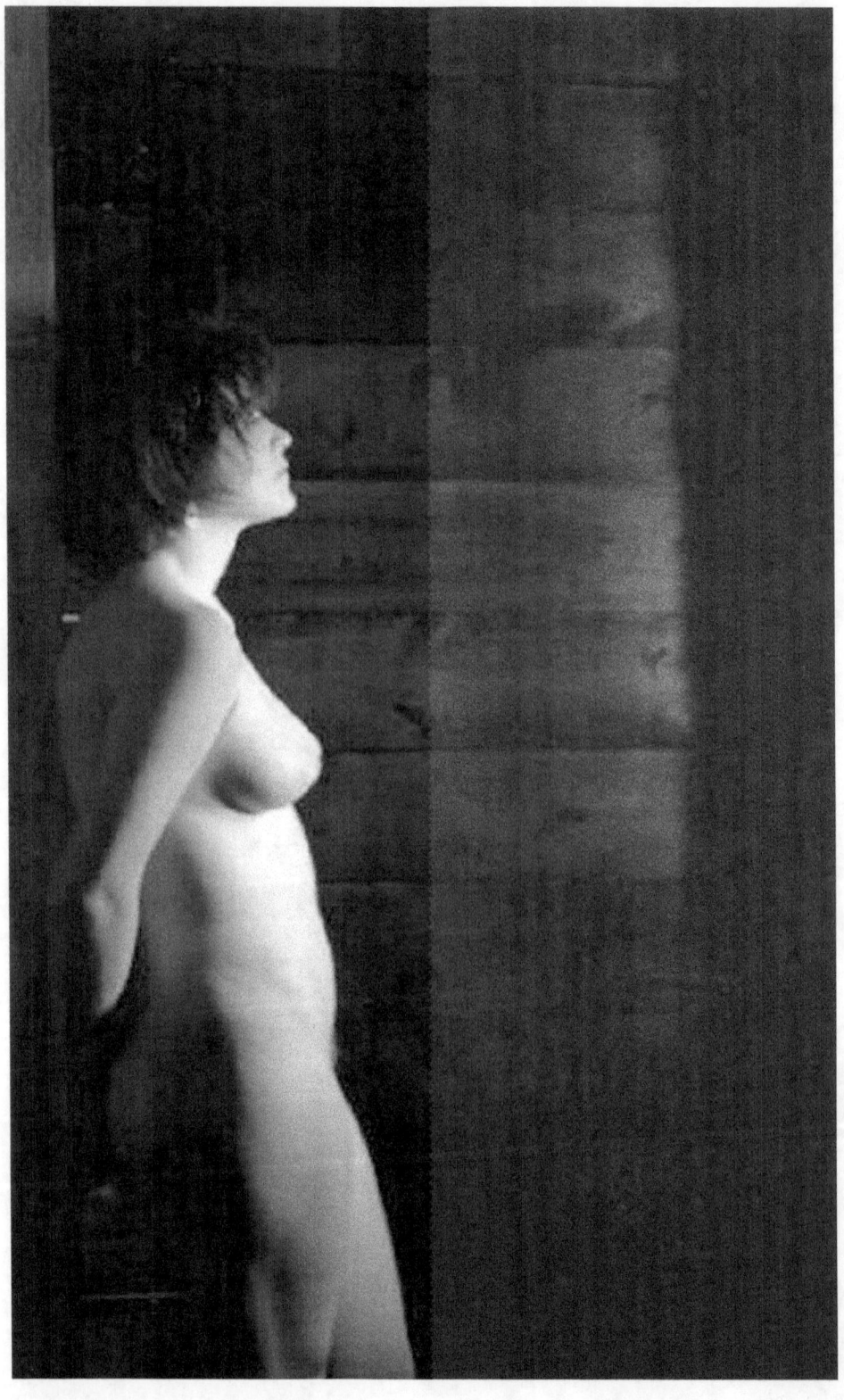

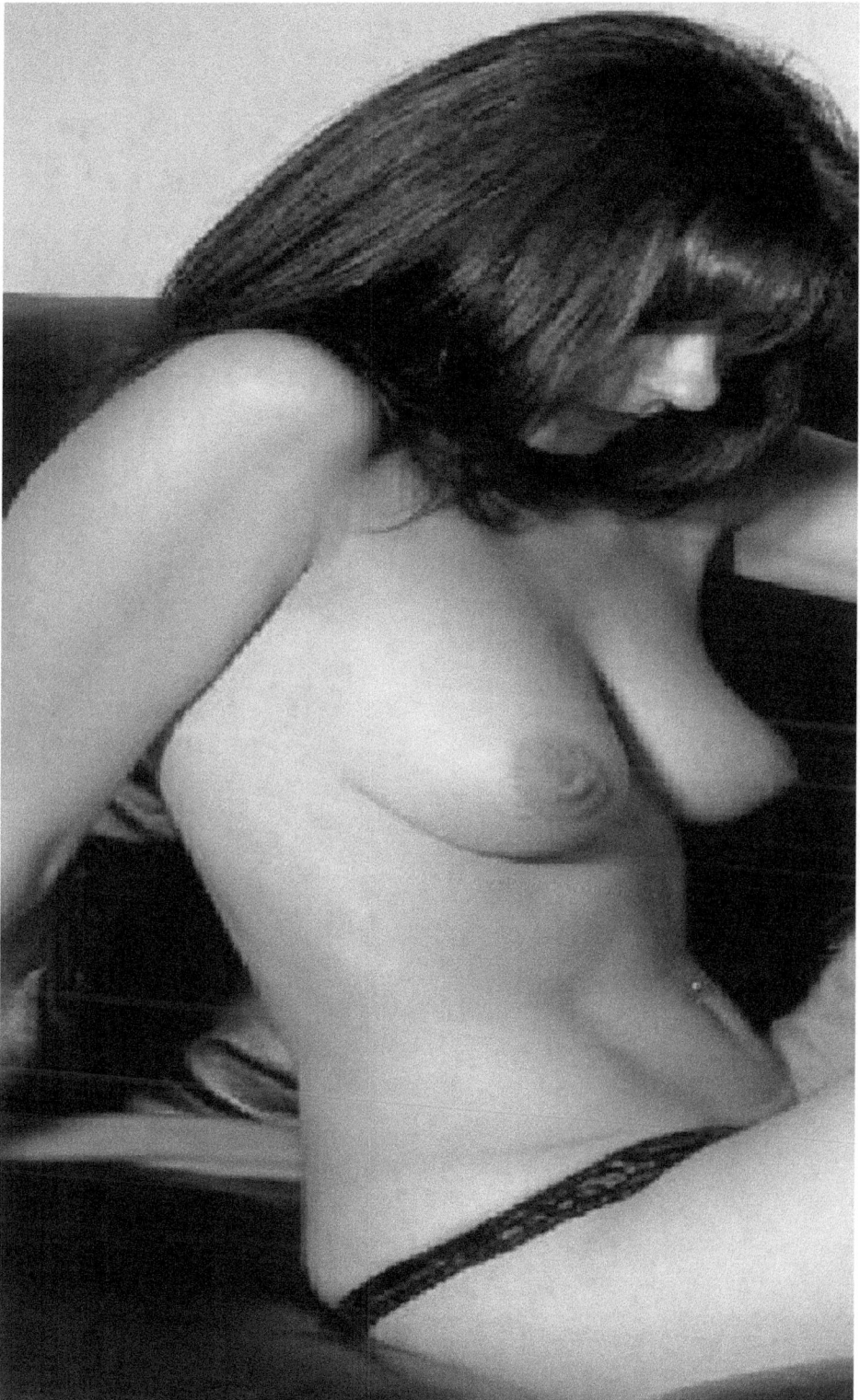

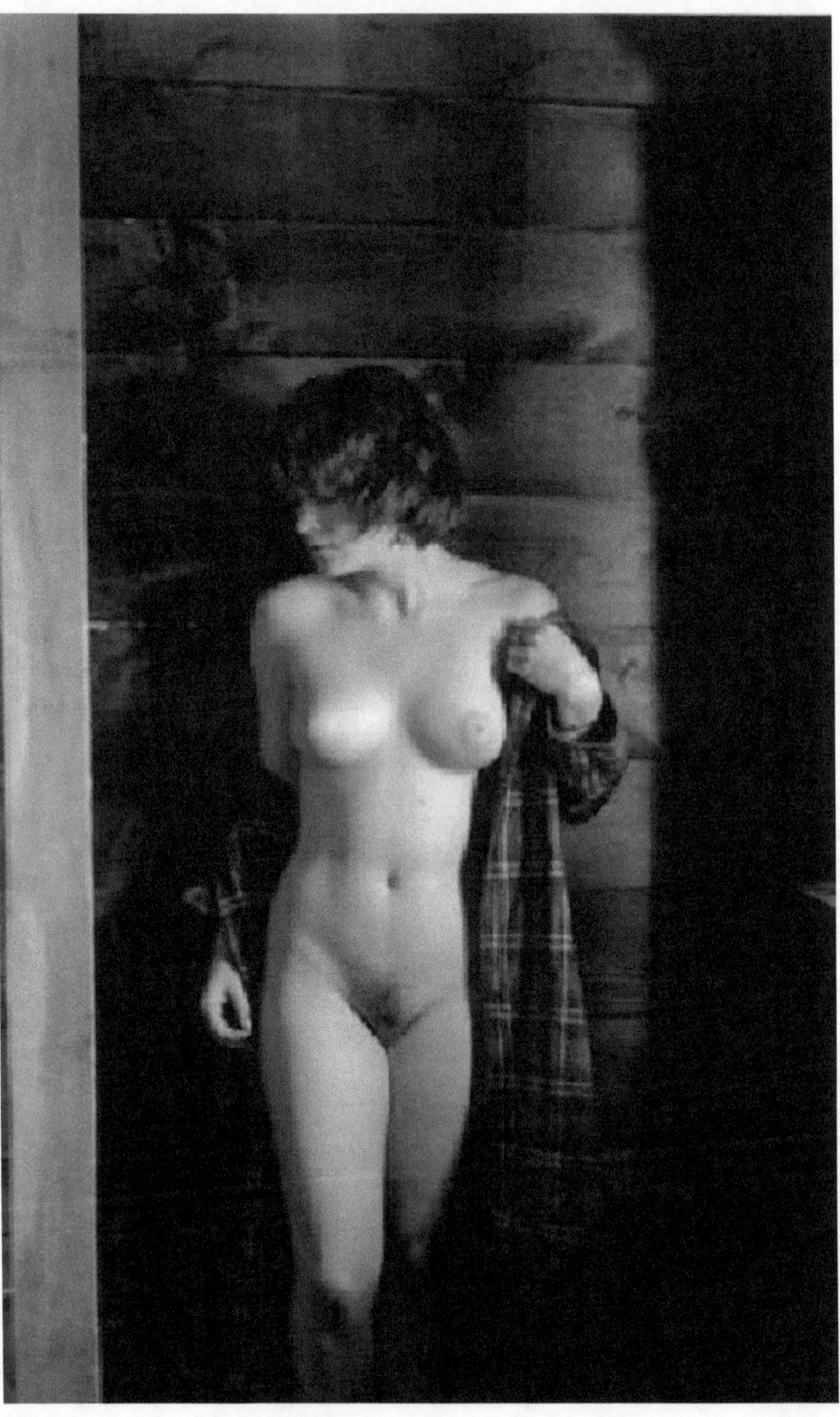

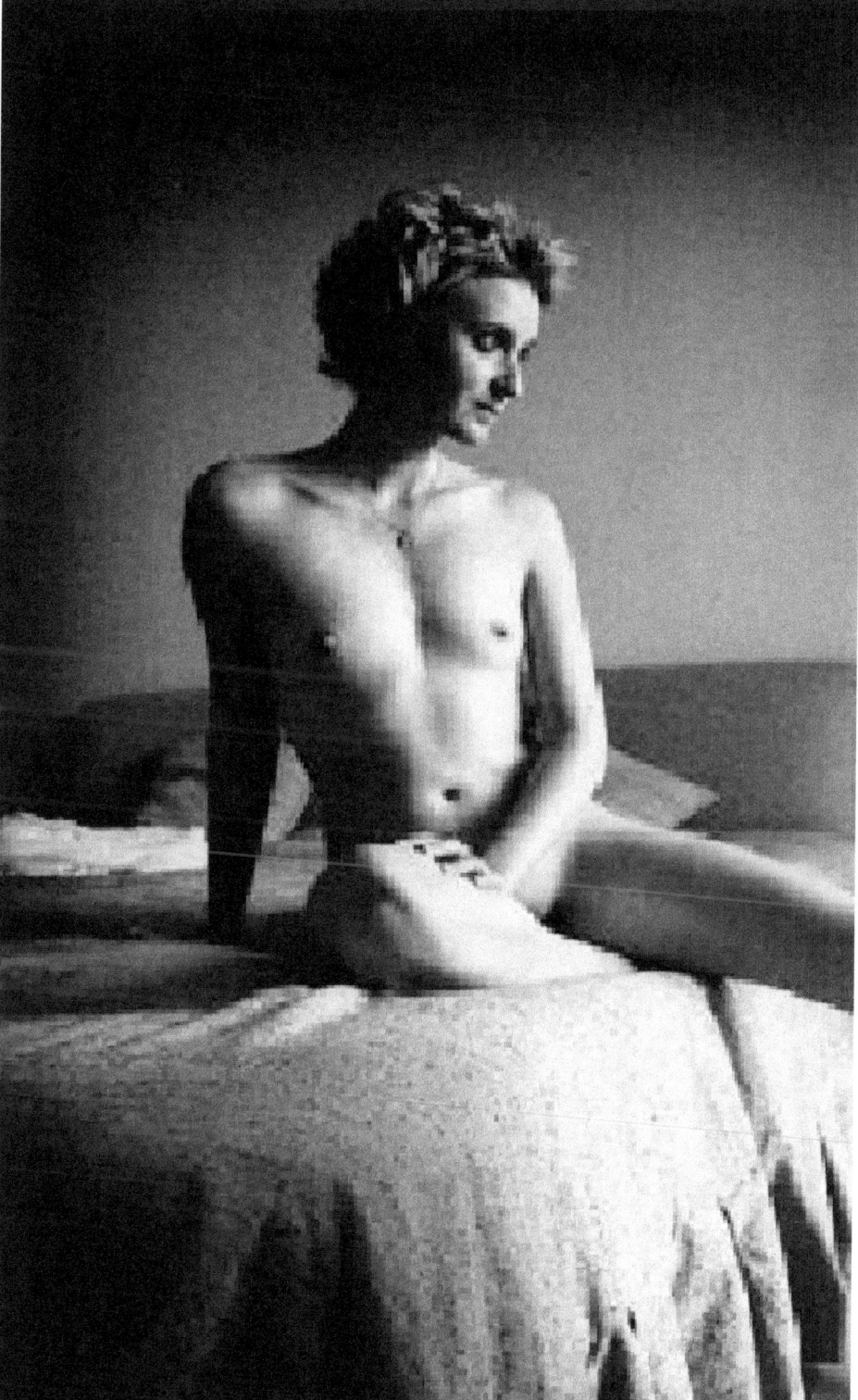

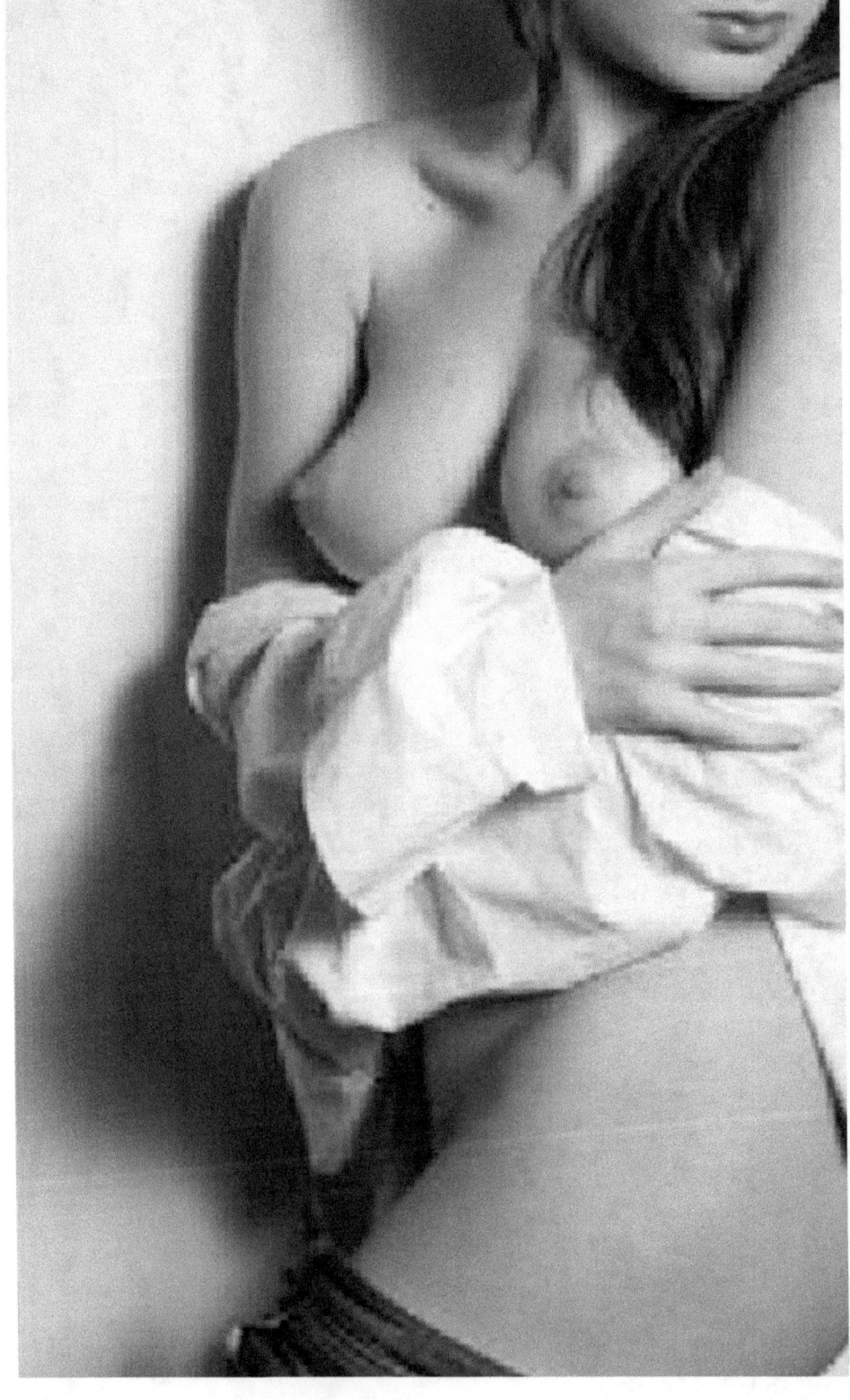

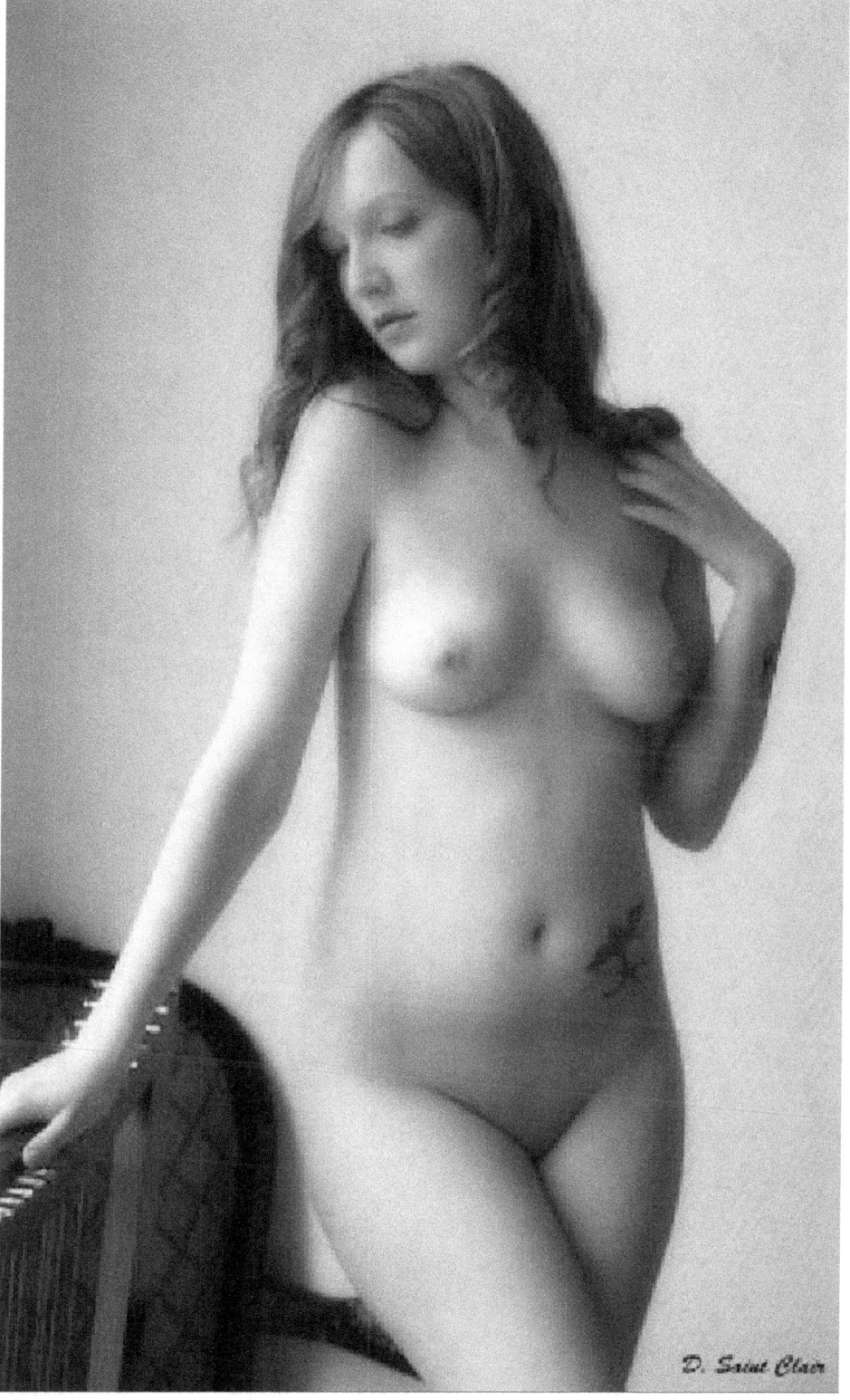

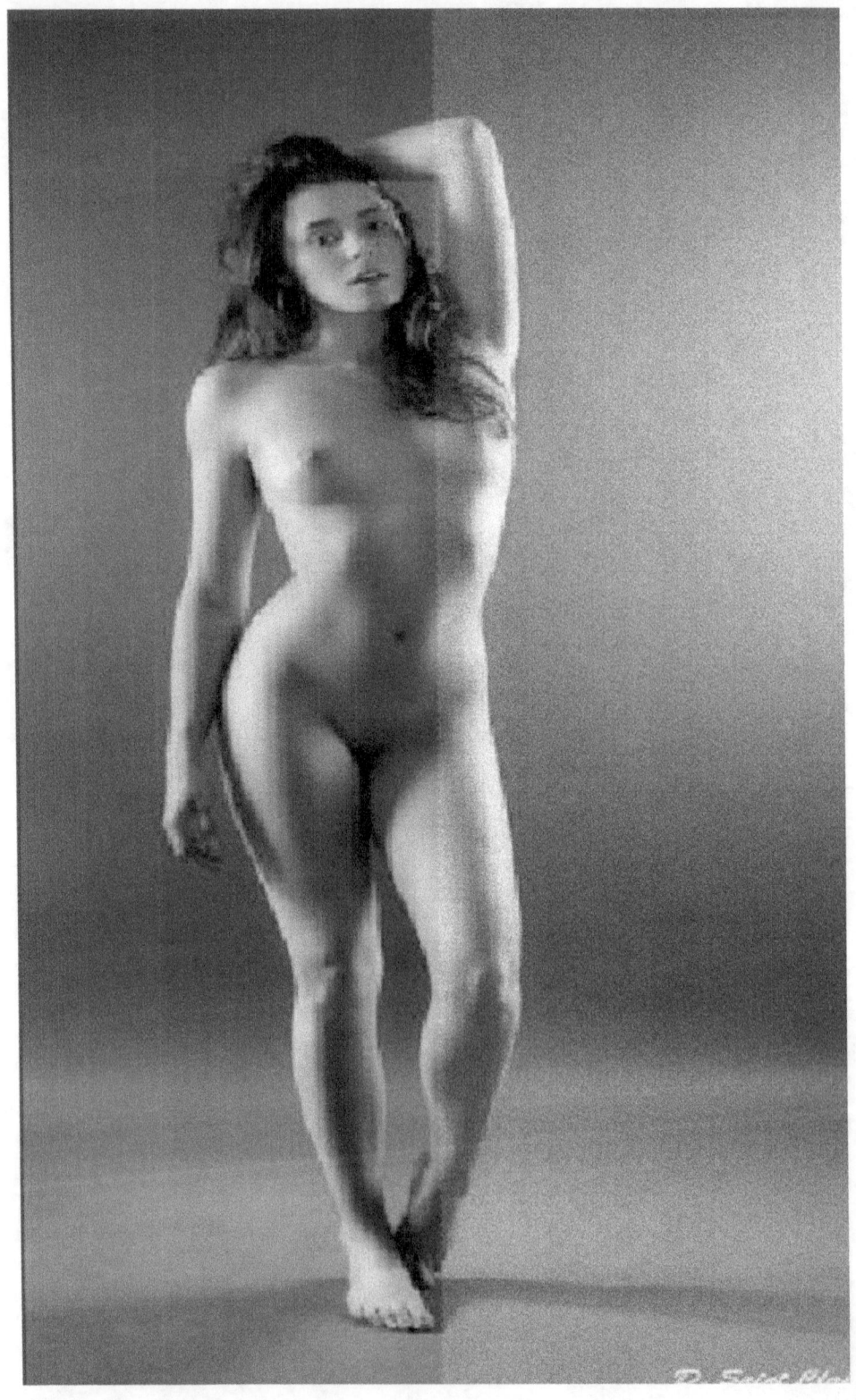

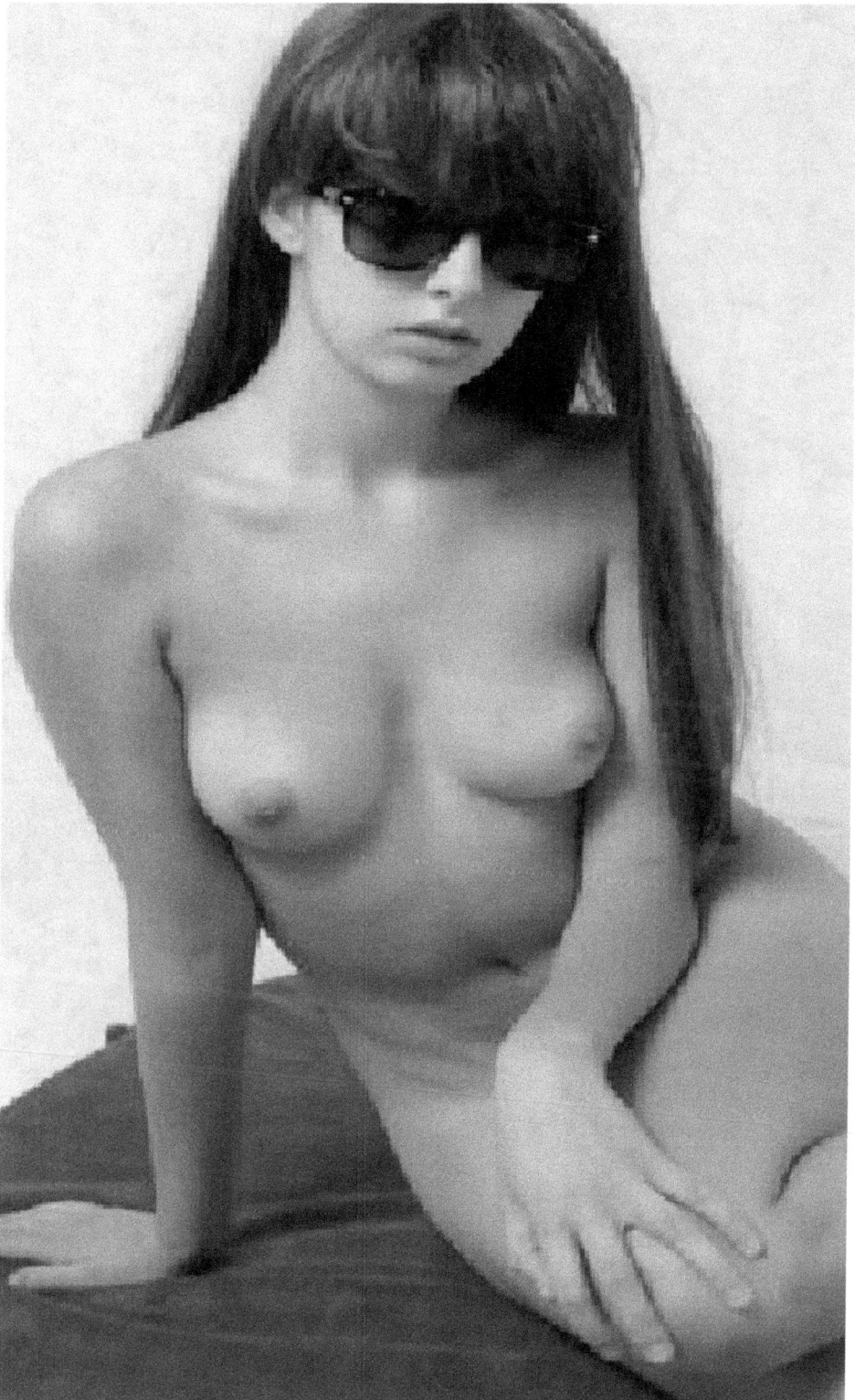

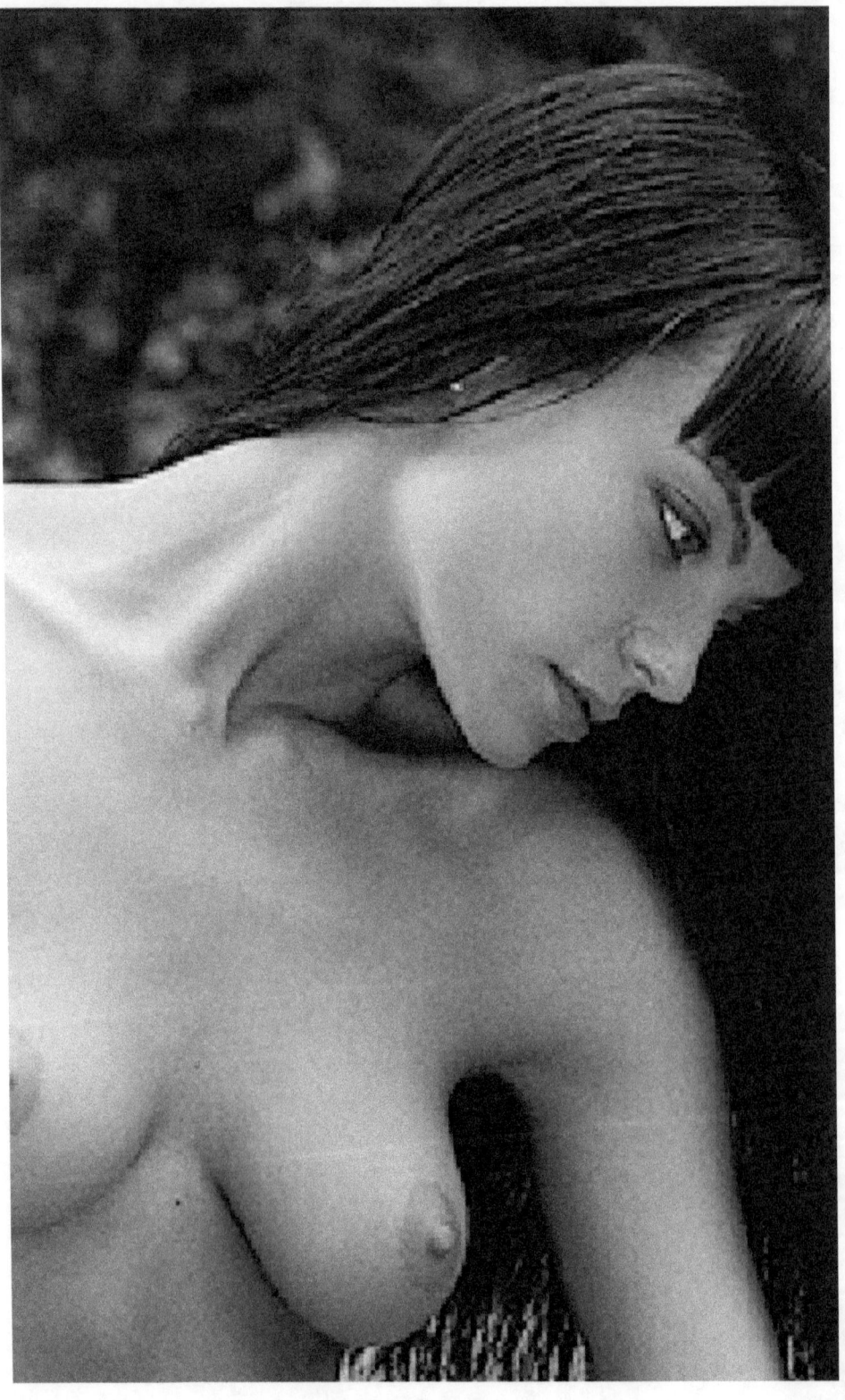

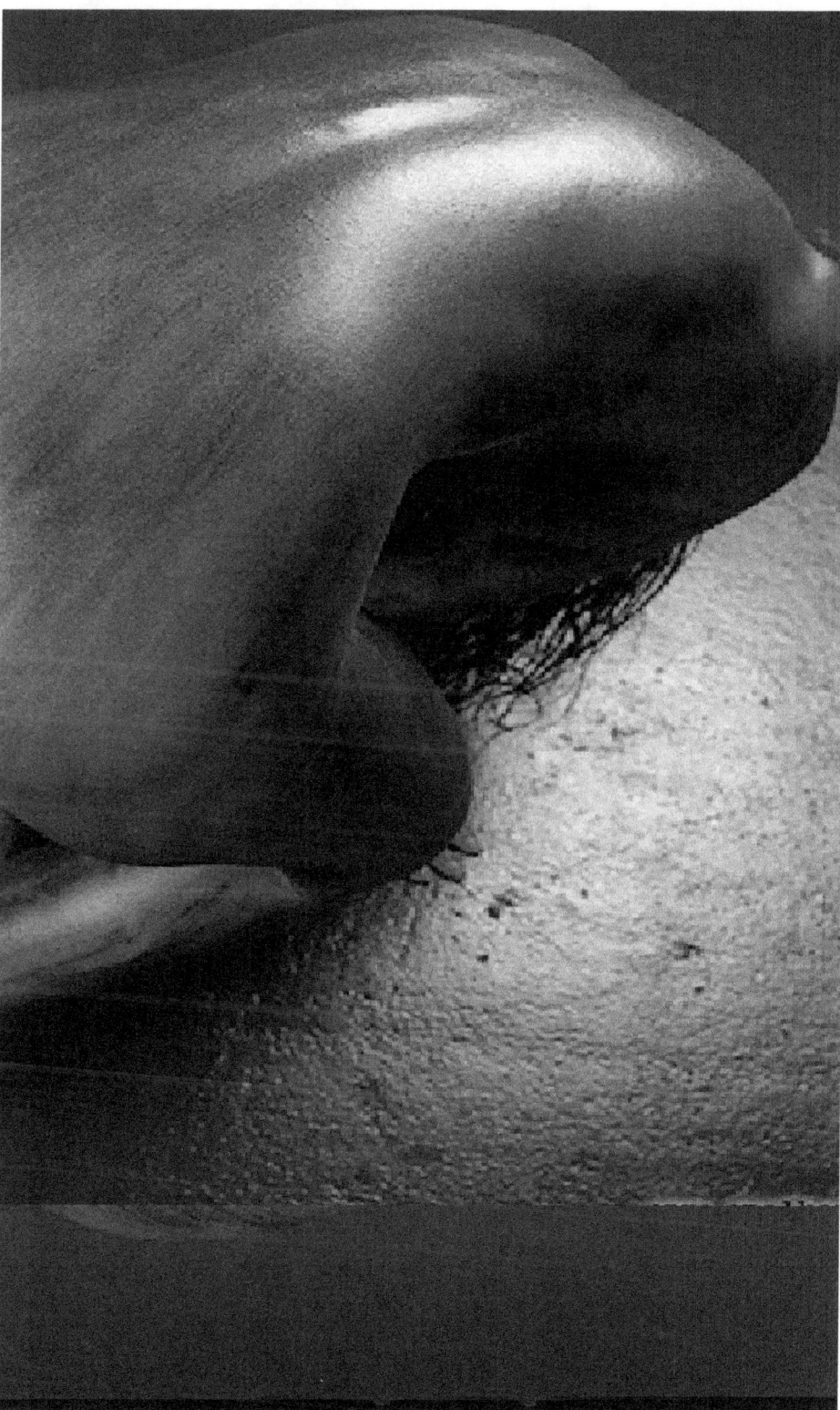

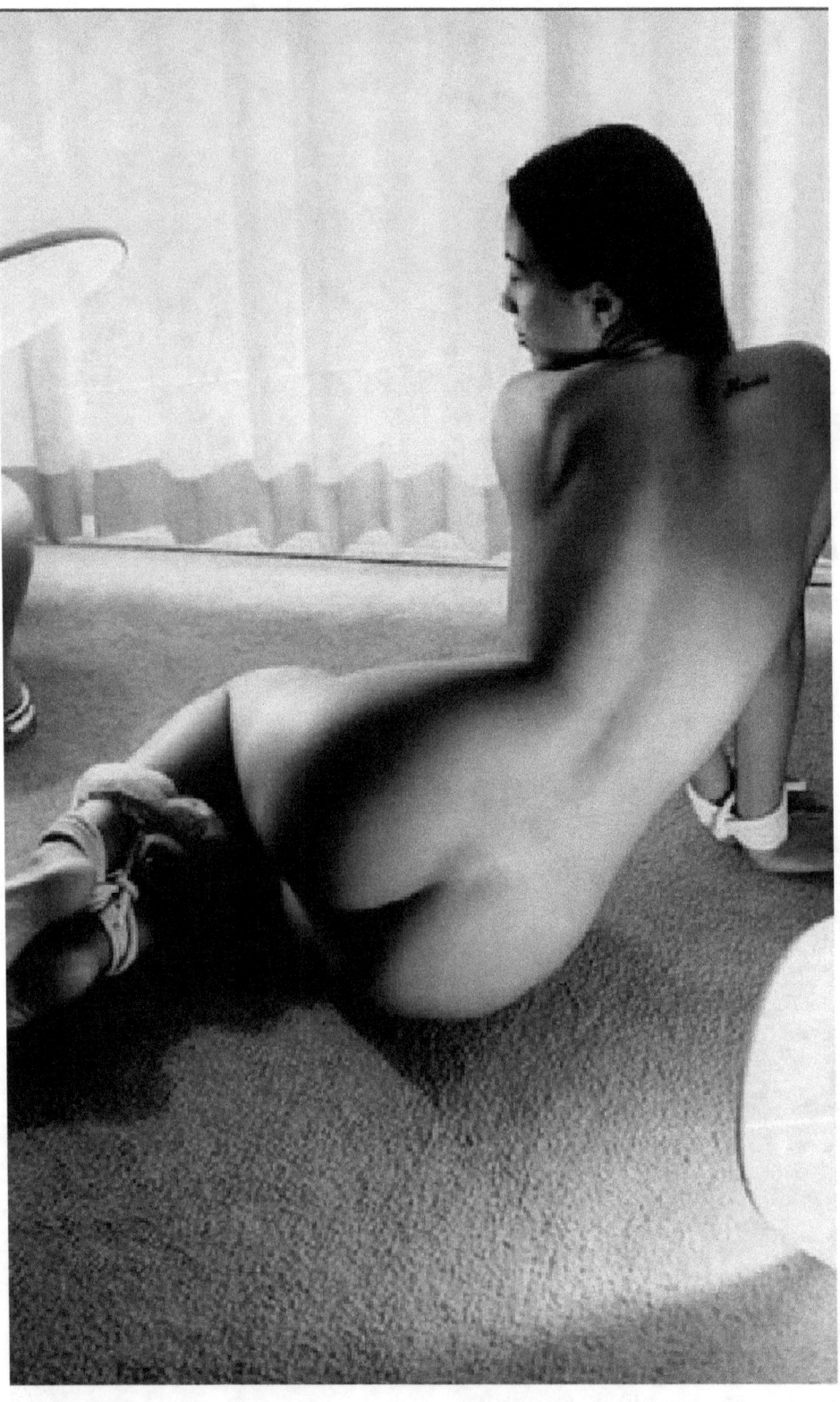

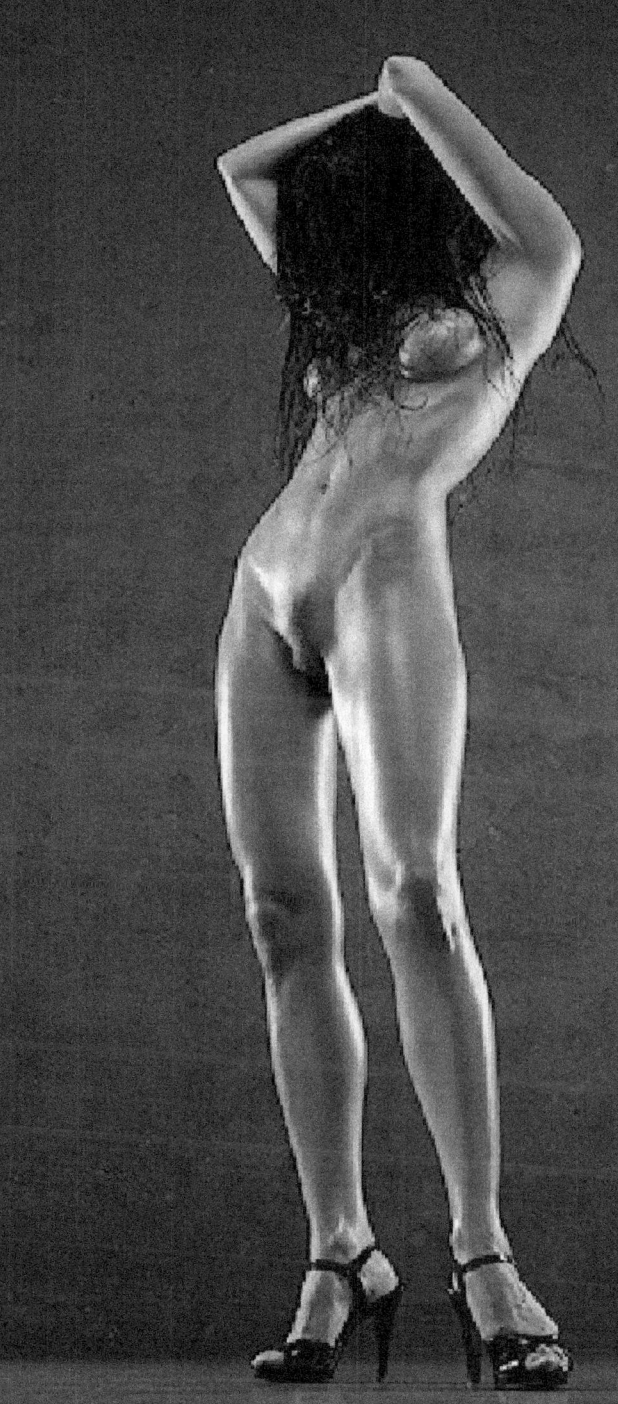

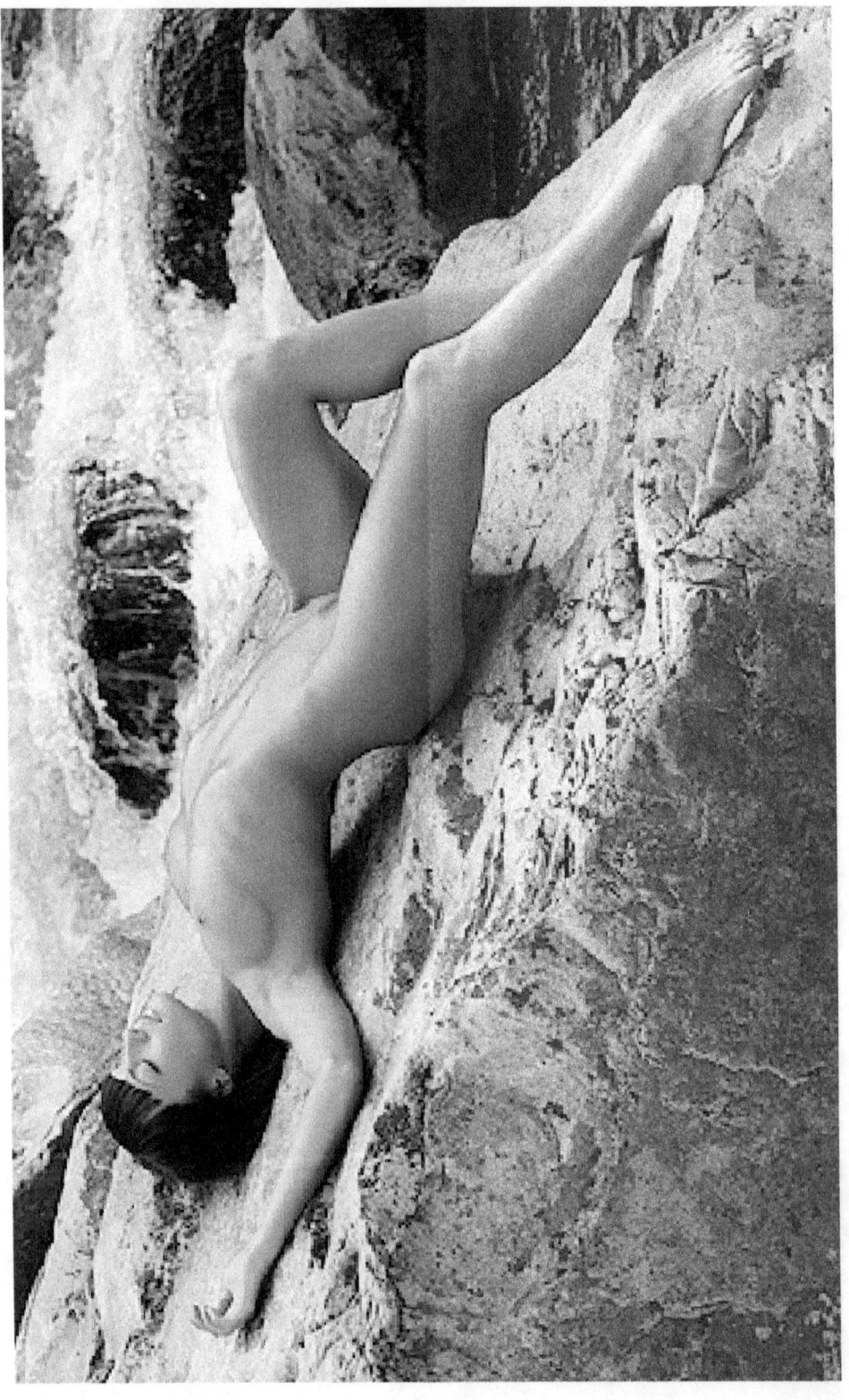

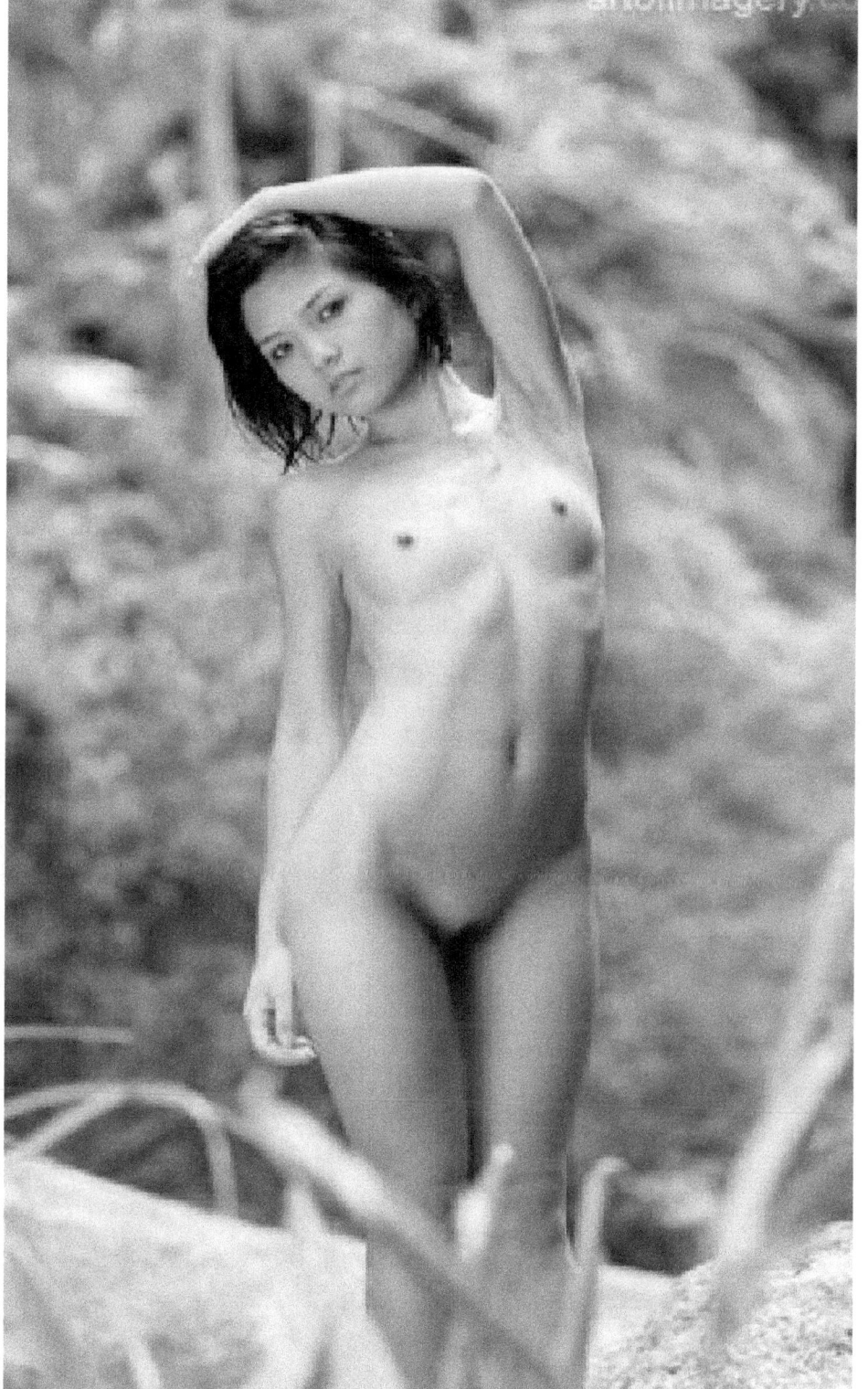

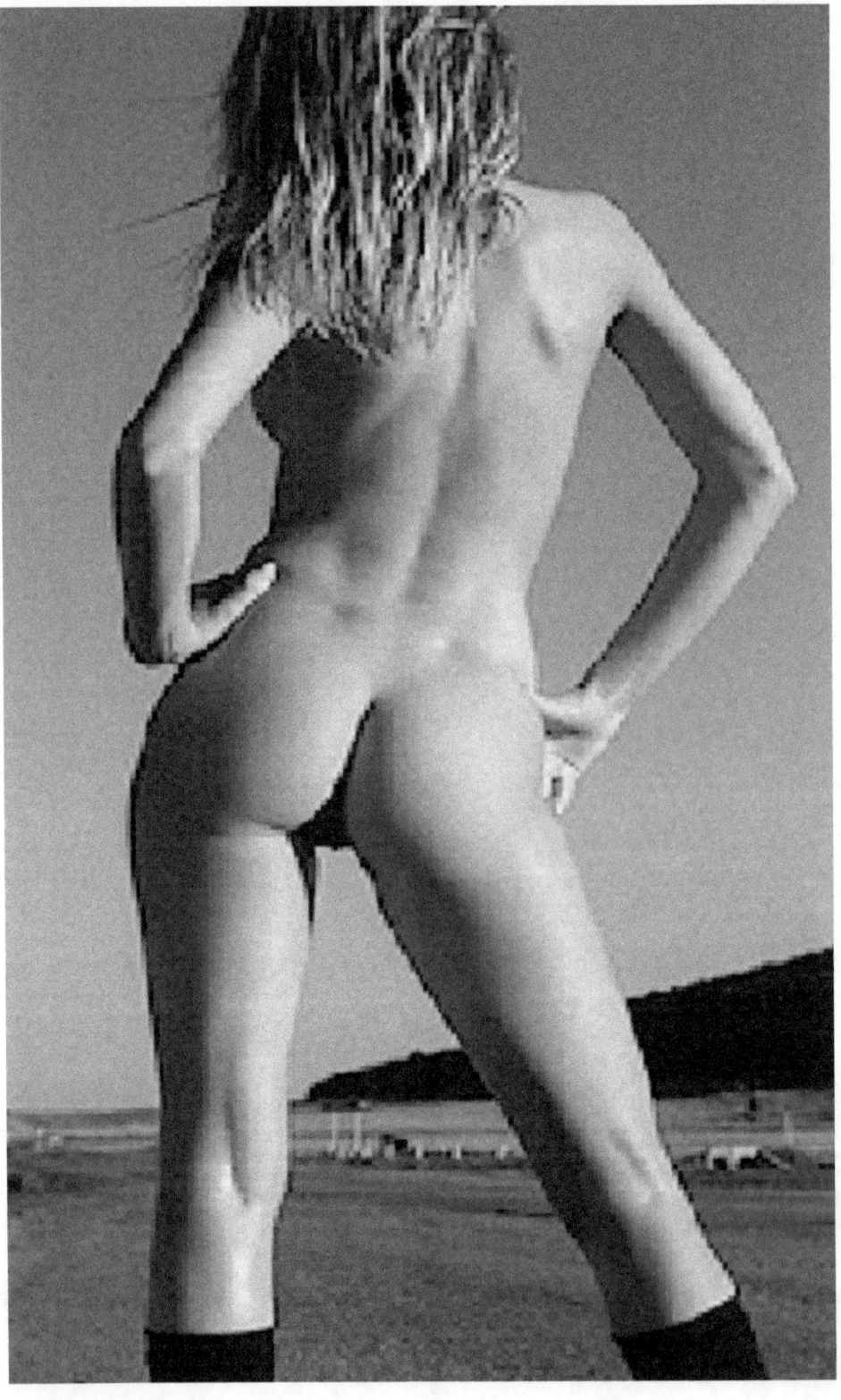

www.ingramcontent.com/pod-product-compliance
Lightning Source LLC
Chambersburg PA
CBHW061521180526
45171CB00001B/281